THE DOG WHO LOVED CHEERIOS

AND OTHER TALES OF EXCESS

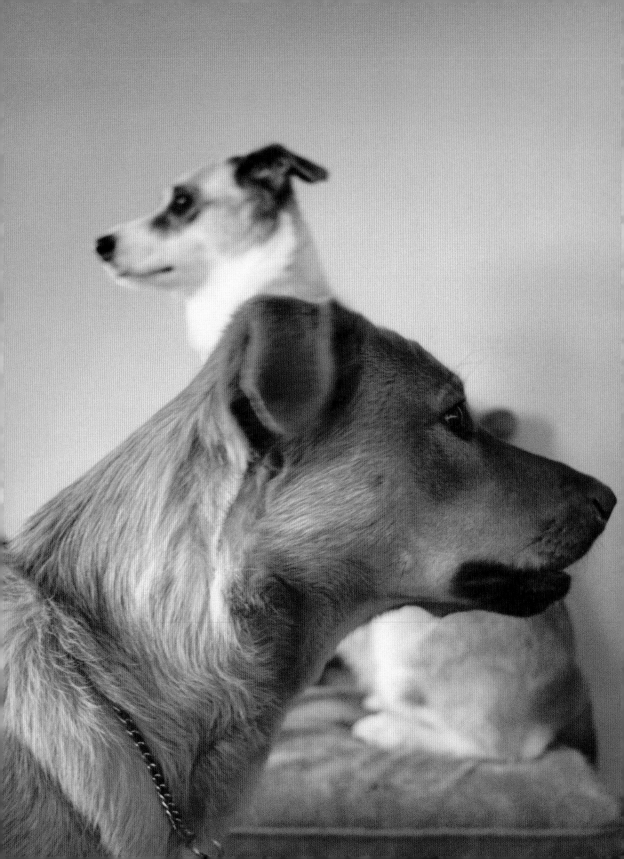

THE DOG WHO LOVED CHEERIOS

AND OTHER TALES OF EXCESS

CAMI JOHNSON

Foreword by KEN FOSTER

Stewart, Tabori & Chang
New York

Published in 2008 by Stewart, Tabori & Chang
An imprint of Harry N. Abrams, Inc.

Library of Congress Cataloging-in-Publication Data
Johnson, Cami.
 The dog who loved cheerios : and other tales of excess / By
Cami Johnson.
 p. cm.
 ISBN 978-1-58479-668-8
 1. Dogs. 2. Dogs--Pictorial works. I. Title.
SF426.2.J65 2007
636.7--dc22

 2007029424

Editor: Ann Treistman
Designer: Alissa Faden
Production Manager: Tina Cameron

Printed and bound in China

10 9 8 7 6 5 4 3 2 1

HNA
harry n. abrams, inc.
a subsidiary of La Martinière Groupe
115 West 18th Street
New York, NY 10011
www.hnabooks.com

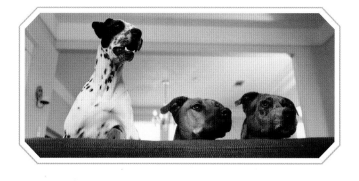

I think we are drawn to dogs because they are the uninhibited creatures we might be if we weren't certain we knew better. They fight for honor at the first challenge, make love with no moral restraint, and they do not for all their marvelous instincts appear to know about death. Being such wonderfully uncomplicated beings, they need us to do their worrying.

—GEORGE BIRD EVANS

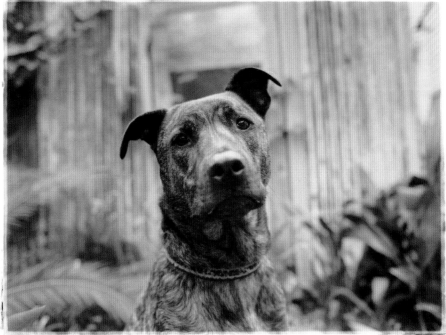

FOREWORD

KEN FOSTER

Don't they say that insanity is when someone repeats the same actions expecting a different result? If so, then many dog lovers, and especially those of us with "devilish" dogs, are probably borderline crazy at the very least.

For example, here's what happens when I decide to relax: I go to Whole Foods, get a few minutes of a chair massage, and buy three or four enormous peanut butter chocolate chunk cookies to bring home, although I never plan to eat them all at once.

And here is what inevitably happens next: while distracted by Sula or Zephyr, I turn to discover that Mr. Brando Foster has devoured the entire stack of cookies. Usually he appears lounging, completely satisfied, on my bed, with the empty cookie sleeve somewhere nearby. (Fortunately, Brando is huge, so the quantity of chocolate is harmless to him.)

Even though the series of events is entirely predictable—Brando always eats the cookies while I'm not looking—it completely erases any sense of calm I might have had. And makes me wonder, once again, about my state of mind.

None of this should be surprising once you've taken a close look at Exhibit A, Cami Johnson's portrait of Brando. Sure, he looks relatively composed, perhaps even entranced by Cami's unflappable nature, but you can see it in the eyes. He's plotting something involving peanut butter cookies.

What then, can we make of someone like Cami, who works exclusively with dog subjects, capturing their mischievous essence on old-fashioned, medium-format film before returning home to prepare dinner for herself and her two dog companions?

Living with a devil dog has its advantages, I'm sure. I have no idea what these advantages are, but I keep hoping to learn them, so that I might better understand what I've become. I can only point to my own little devil, Brando, to highlight some of the finer points that distinguish him and the rest of Cami Johnson's rogues gallery, many of whom I've been privileged to meet.

Sure, any dog can steal some table food or chew on a sneaker, but who—aside from Brando—could top this: Once, when he was just a year old, Brando calmly approached a woman in a Manhattan dog run, politely took her skirt in his mouth and ripped it from her waist. It was a silk, one-of-a-kind designer item. To make matters worse, we were in the middle of a training seminar led by Andrea Arden, who was in the middle of answering a question about dog behavior, specifically when it warrants removal from the park. "That," she said, pointing toward the skirt-decorated mouth of my dog and the skirt-less woman, "would be an example of when to remove your dog from the park."

Brando was the only one of us who wasn't embarrassed, and perhaps that is the thing I admire about him most.

Brando was also not at all embarrassed when he stole a wallet out of a stranger's back pocket as we were walking down the street. This was an extension of one of his favorite pastimes: stealing empty plastic bags from people and eating them, quickly. One day he grabbed a bag in the dog park and did half a lap around the park before coming to an abrupt stop, and, realizing what the bag contained, dropped it on the spot. Still, not embarrassed.

His fear of stuffed animals: not embarrassing to Brando. We frequently had to find an alternate route home in order to avoid a discarded plush Snoopy or Pooh that some neighborhood child had outgrown. Recently, when I brought home a miniature iron-cast figure of a German shepherd, Brando growled at it until I put it on a mantel safely out of reach. I woke up in the middle of the night to find the two of them facing off against each other. Then there was the time he hid a bone in the shower drain, taking the time to replace the metal grid. Or the day he ate a rubber glove. Actually, it was the day after that was memorable.

With dogs like this, one can only hope that they outgrow it, yet when they do, it is hard not to feel nostalgic for those hectic days of constant chaos and panic. Not to worry. That old devil dog will reappear. Here is the gift Brando gave me last Easter: I arrived home to discover he had found a carton of a dozen dyed eggs that had been a gift from a neighbor. Brando had carefully licked each of the eggs clean, and was nestled with them in my bed, waiting for them to hatch. Oh, what a smile he had.

How could I not love him?

Go ahead, look at him. I know you can see all of this in his face. Cami's photographs achieve what the best portraits do, revealing that dogs are made of equal parts sinner and soulmate—essential qualities in any best friend.

BASIL

MOST CARNIVOROUS

Basil has never met a type of meat he didn't like to eat. He is probably the only dog who responds to the word "Braunschweiger," not just because he is part German shepherd, but also because he knows that it is a very tasty liver paste, by far one of his favorite meat products. Basil thanks the dog gods every day that he was not adopted by vegetarians.

Use extreme caution when offering meat to Basil. Let's just say that sometimes the hand that feeds Basil is also the hand that Basil feeds on. It is best to toss the meat product to Basil from a safe distance. Never get complacent about your meat delivery technique, regardless of how close your friendship with Basil becomes. Basil just cannot control the excitement that he feels when meat is in sight, and getting that meat always trumps the safety of the meat giver. Even when you don't have meat in your hands, you should be careful. To Basil, your fingers look like five tiny sausages, and if you offer up your hand for a sniff, he'll behave like a shark taking chum from a boat. This has led Basil into much trouble—all the way to the doggie slammer, in fact. Luckily for Basil, he is normally a very sweet dog, and he was released on good behavior once it was determined that he would not taste anyone's fingers as long as they were not put in front of his face.

Somehow, Basil still has many fans; even most of his victims remain loyal, lifelong friends and laugh at the thought of those who will follow in their unsuspecting footsteps. Don't let his name fool you. Basil is not an herbivore!

Age 13 years	Weight 170 pounds
Breed New Orleans Black & Tan (aka shepherd mix)	
Favorite Toy Empty plastic bottles with cap and ring still intact	
Favorite Pastime Removing cap and ring from empty plastic bottles	

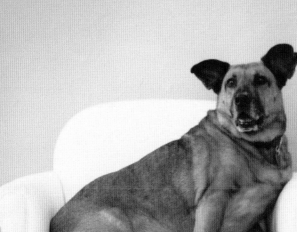

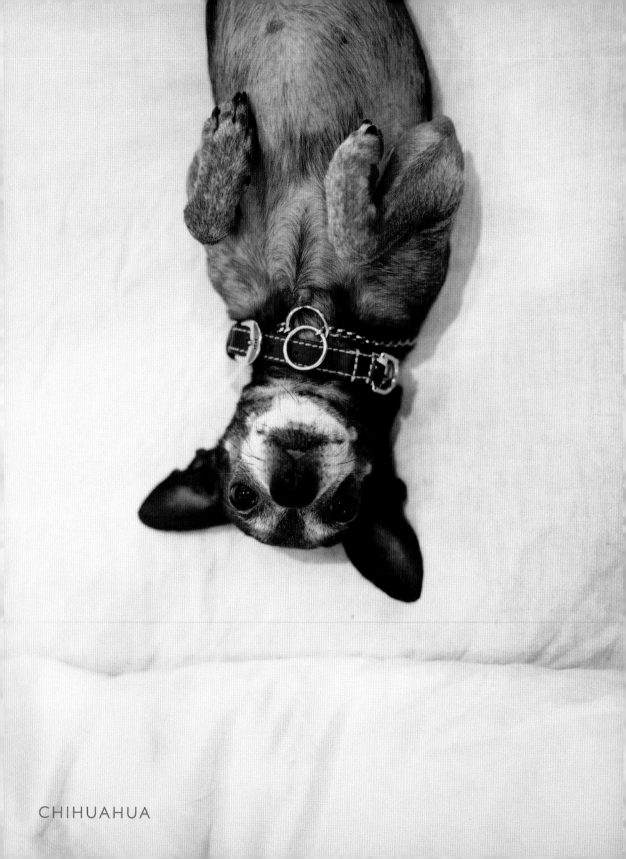

CHIHUAHUA

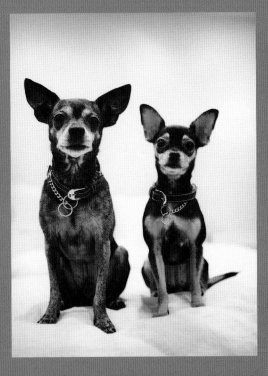

ROLO & ELLA

JESSE

At home, Jesse is a very prim and proper English setter. She considers herself to be extremely well bred and is very much above being a dog. Jesse does not shake hands or sit on command—tricks are for dogs. Her neck is bare while she is inside the house—collars are also for dogs. When she sits in the armchair—floors are for dogs—she strikes a very regal pose and awaits the pampering that she knows she deserves.

At the park, something changes in Jesse: the prim and proper (some would say snooty) English setter turns into a wild animal. Nothing can stop her from finding the muddiest puddle in the park, and once she finds it, she's in it. She doesn't merely wade in it; she lies down in the muddy mess and submerges her entire head with unabashed glee. (She also experiences selective deafness during these times and somehow cannot hear her owner screaming at her.)

Once she's done at the puddle, Jesse shakes the mud out of her eyes and takes off in search of her next-favorite park pleasure: deer poop. She is very particular about this. It can't be just any kind of poop, it must be deer poop. And as with the mud puddles, when she finds it, she is in it. She rolls around in it until she is wearing it (and again, those screams coming from her owner are mysteriously inaudible to Jesse).

As soon as she feels sufficiently coated in mud and deer poop, Jesse returns to her (now hoarse) owner and is whisked off to the nearest hose for a thorough washing. Once all signs of mud and poop have disappeared, Jesse gets into the front seat of the car—back seats are for dogs—and reigns as princess once again.

Age 6 years	Breed English setter
Weight 50 pounds	Favorite Toy Toys are for dogs
Favorite Food Bacon	

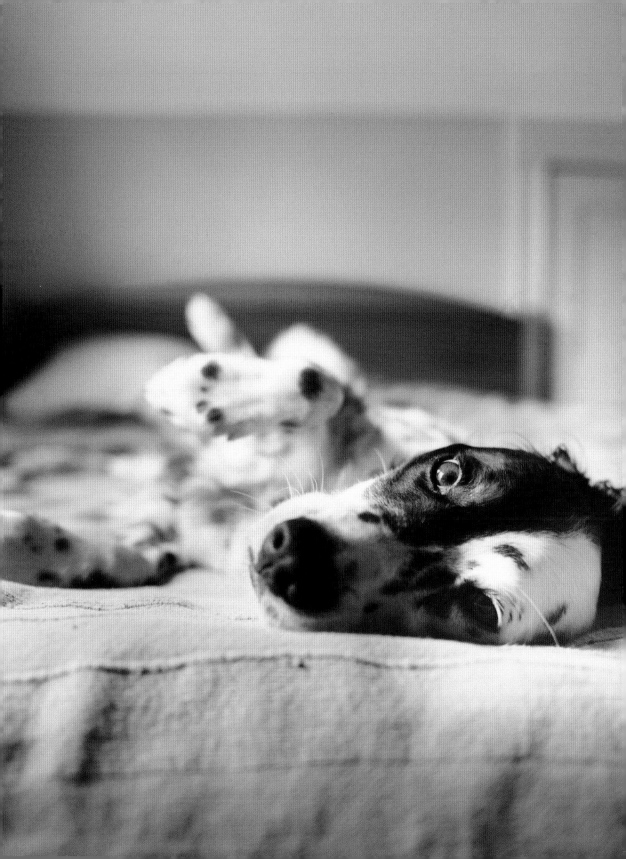

ARLO

Arlo comes from a long line of distinguished Old English sheepdogs. These dogs are bred for their fearlessness and protectiveness, necessary traits for herding sheep and keeping predators away. And although Arlo looks like a typical Old English sheepdog, he's known throughout his neighborhood for his *fear of everything*.

The great outdoors is nothing but a great big nightmare for Arlo. Most dogs, on hearing the word "walk," get very excited and head for the door. Arlo hears the word "walk" and runs as far from the door as he can get. Once Arlo is coaxed (to put it nicely) outside, the key is to avoid the things that scare him. Cars scare Arlo. Trucks terrify him. Ambulances . . . well, by the time you actually see the ambulance, it's too late because the siren alone causes a panic attack that renders Arlo a needier candidate for medical services than whoever called for the ambulance in the first place.

If you do manage to walk Arlo on a relatively traffic-free day, there are still many other things to avoid. Arlo is afraid of anything that makes noise; leaf blowers and lawn mowers are particular sources of anxiety. Don't even bother trying to walk Arlo on trash day. He can't cope with the loud garbage trucks and the big scary trash cans on the sidewalk. He's even afraid of the trash-can lids. Forget walking by them; Arlo will just turn into a 75-pound statue.

Arlo's psychiatrist says that "Arlo is a dog who longs for a more natural, pastoral setting than the urban one to which he has been confined. He believes he is just protecting his owners from the Traffic Terrors, the Noise-Making Predators, and the Very Scary Trash-Can Monsters." That might be a little more convincing if the first clap of Mother Nature's thunder didn't send Arlo into complete panic mode.

So . . . while Arlo is a lovable house dog, it's probably a good thing that Arlo is *not* responsible for any sheep.

Age 4 years	Weight 75 pounds (4 pounds of which is hair)
Breed Old English sheepdog	Favorite Toy Stuffed Sheep
Favorite Food Any dog bone that costs more per pound than lobster	

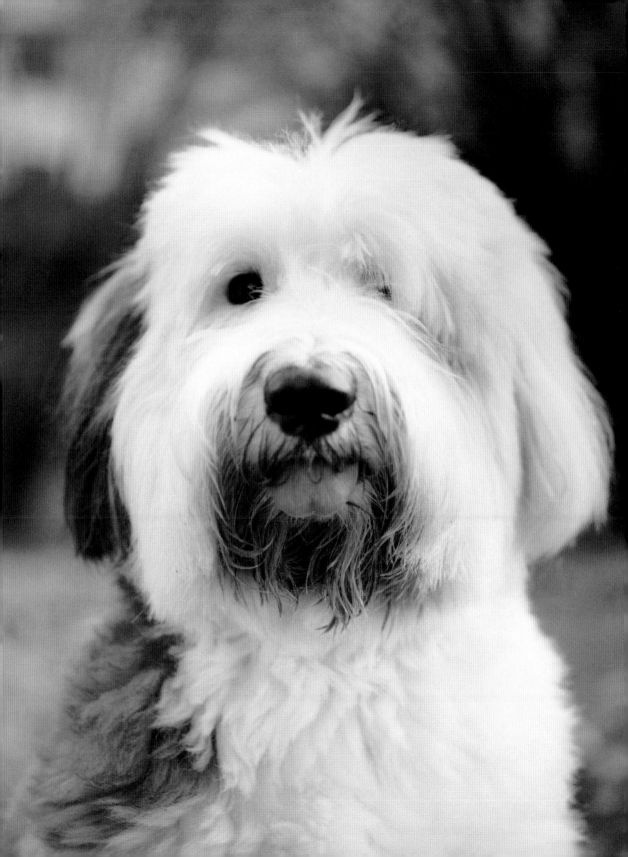

ISABELLA & HUGO

WHAM! POW! BAM! Those are the sounds that the Dynamic Duo of Hugo and his fearless sidekick, Isabella, imagine as they battle the diabolical cat criminals in their house. These cats are forever trying to steal lap space away from lap dogs. Hugo and Isabella are lap dogs, and as everyone knows, there is no such thing as a lap cat.

Defending lap space in their house (or the Pug Cave, as they like to call it) keeps them very busy, as they live with four evil cat villains and only two human laps. This makes lap space prime property, and Hugo and Isabella must work as a team to fend off the felines. When a lap is created, Hugo will be the first to immediately jump up and occupy the lap while Isabella keeps an eye on the other human (Isabella knows that the humans will often sit in the same room together and create two laps). If it seems unlikely that a second lap will be created, Isabella will jump up and share the lap that Hugo is defending and they will mentally high-five each other as they watch the cats sadly circling, lap-less, below.

Things do not always go so smoothly, though. Sometimes when waking up from a nap, Isabella will find cats occupying both human laps. Holy Cat-astrophe! Isabella will quickly alert Hugo, via the Bark Phone, that there is trouble in Pugtham City, and the Dynamic Duo will run together to the scene of the crime, barking their pug heads off. If this tactic fails, the Capeless Crusaders must now take more drastic and dangerous action: jumping onto the couch, inching closer and closer to the cats, sometimes "accidentally" bumping into them, and eventually causing them to leave in a huff. Mental high-fives once again ensue, as the pugs regain their all-important lap space.

Defeating the evil lap stealers has just gotten much harder, as an 85-pound Labrador recently joined the lap-stealing crime family. Will the Dynamic Duo succeed? Tune in next week, same Pug Time, same Pug Channel!

Age 7 years	Weight 21 and 23 pounds
Breed Pug	Favorite Food Anything edible
Favorite Toy: The other one's Nylabone	

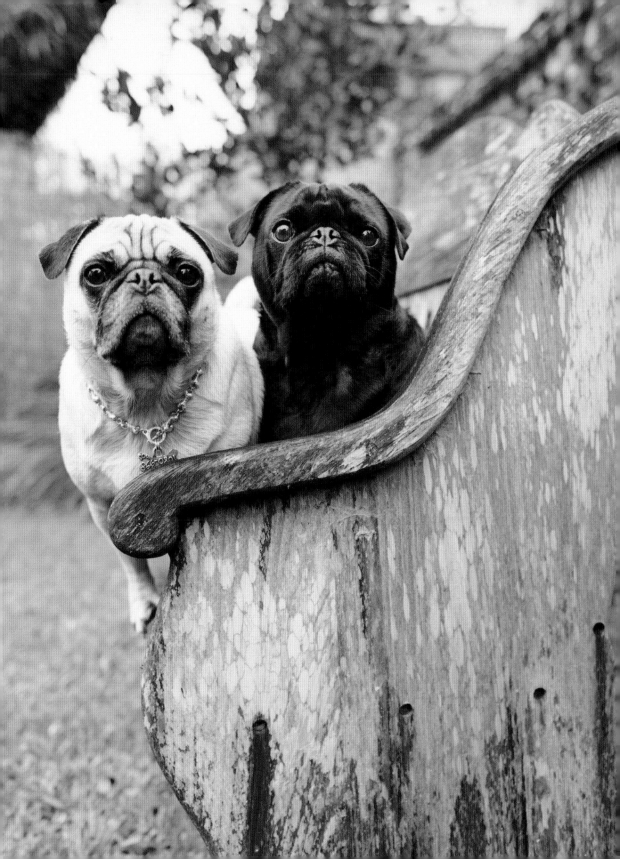

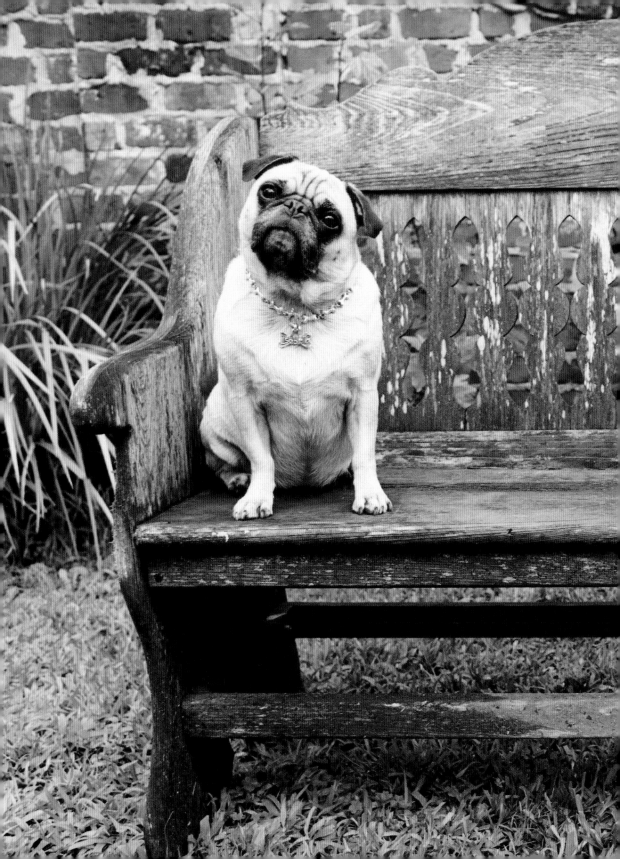

CHLOE

Chloe was the center of attention in her house. The world seemed to revolve around her. All of the toys were hers, all of the treats were hers, all of the playtime was hers, and she was happy.

One day, everything changed. Her owners had a baby. Suddenly attention shifted away from Chloe and onto this new little creature who, it might be worth noting, could not sit, roll over, or shake hands! This shift of attention to a seemingly untalented and at times rather noisy creature sent Chloe into a deep, dark depression.

Some months later, however, as Chloe was moping around the kitchen mourning the loss of her household reign, she noticed something unusual: a small scattering of Cheerios on the floor beneath the baby's highchair. As she quickly began to clean up the delicious mess (the three-second rule does not make sense to Chloe), she felt something fall on her head . . . another Cheerio! She looked up and saw that the baby was providing a steady stream of Cheerios from above. This was very exciting! Chloe began hanging around the baby more often and quickly realized that the baby was like a human Pez dispenser, providing a constant supply of all sorts of food items. Chloe's owners seemed to approve of this new symbiotic relationship between dog and baby. They never needed to pick up after the baby made a mess of mealtime. Chloe would sometimes even lick the baby clean. For some reason her owners were not too fond of that practice, so it had to be done quickly and covertly.

Chloe's depression had officially ended, and she embraced her new status as the mealtime babysitter. When Chloe's owners brought home a second baby, Chloe did not get sad at all. After all, the food opportunities had just doubled.

Age **5 years**		Weight **70 pounds**	
Breed **Golden retriever**		Favorite Food **Cheerios**	
Favorite Toy **Mr. Carrot**			

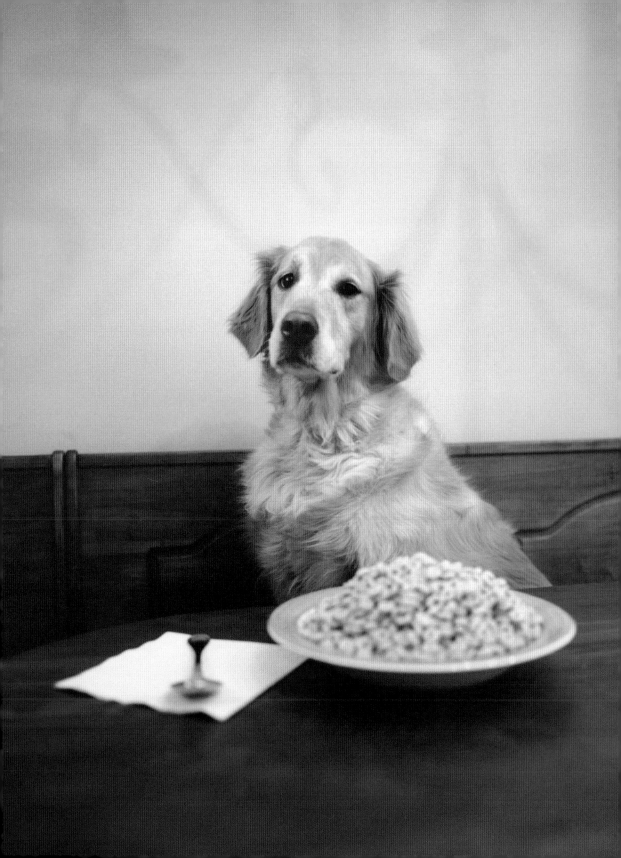

HOOLIE

MOST PAVLOVIAN

If the furniture seems to be in a different place every time you visit Hoolie's house, it's not because his owners are trying to perfect the feng shui of their home; it's because Hoolie has an uncontrollable response to the doorbell that would make Pavlov proud. Hoolie hears the doorbell and goes into a complete frenzy, barking wildly as he runs from window to window, knocking chairs and tables this way and that as he tries to see who has rung the bell.

While Pavlov's dogs drooled at the sound of a bell in anticipation of the forthcoming treat, Hoolie's bell response is in anticipation of a different kind of pleasure: houseguests. Hoolie loves people, and when that bell rings he can hardly contain his enthusiasm. He certainly makes his guests feel welcome; he jumps all over them, leaping straight up and kissing their faces. He then celebrates their arrival by sprinting throughout the house, again knocking the furniture around and barking excitedly.

Hoolie's owners are not too enthusiastic about his redecorating techniques, and have trained all of their friends NEVER to ring the doorbell—this has proved to be much easier than training Hoolie. But after all, Pavlov's conditioning techniques are not just for dogs, and 67 pounds of drooling excitement has been very effective in extinguishing doorbell-ringing behavior.

Unfortunately, it is taking much longer to train the pizza delivery guy.

Age 3 years	Weight 67 pounds
Breed Pit bull mix	Favorite Food Carrots
Favorite Toy Chicken stuffed animal	

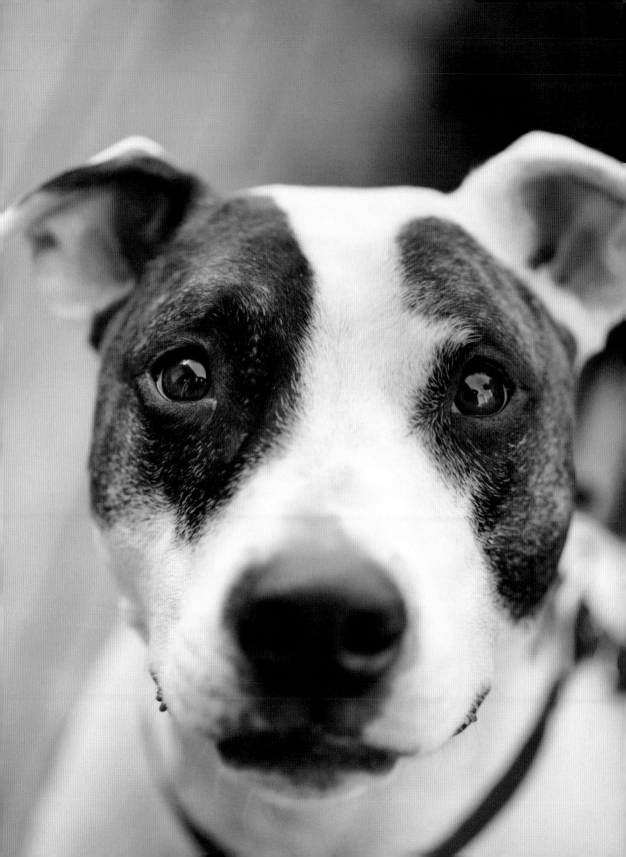

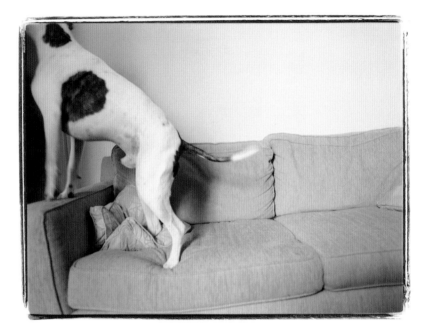

SNICKERS

TINIEST HUNTER

Snickers is a hunter. And he's hunting rabbits, so be very, very quiet. Snickers knows that the best time to find rabbits is early in the morning, and this is his favorite time to go for a long walk. It's actually one of the few times that he willingly goes for a long walk (most other times, a block is his limit before he sits down and refuses to move). But rabbit hour is different. During his rabbit walk, Snickers moves with determination and concentration. Every yard has rabbit potential. When he spots a rabbit, he immediately stops and stares at his prey with his front paw raised, as if he's part pointer. The rabbit also freezes and stares back. This staring contest continues until the rabbit decides to make its move, at which point Snickers charges after it with the speed of . . . well, a jack rabbit. Unfortunately (or fortunately, if you're the rabbit), Snickers has no learning curve and consistently forgets that he can only run fifteen feet before the length of his lead runs out, bringing his hunt to an abrupt stop as the rabbit scampers away. Hope springs eternal as Snickers begins the hunt all over again, with similar results. Snickers has caught a grand total of zero rabbits.

After a long afternoon dreaming of his missed rabbit opportunities, Snickers again puts on his hunting cap. Dusk has arrived, and though the rabbits are all safely sleeping, the toads are just waking up. Let the toad hunt begin! Snickers stalks the toads in a similar manner to the way he stalks rabbits, but when he finds one, there is no time for a staring contest. Snickers must spring into action, and he does in fact "spring" straight up into the air and right on top of the unsuspecting toad. Unfortunately for Snickers, these toads have a built-in Yorkie Defense System: the glands behind their ears squirt eye-stinging, illness-inducing toxins at their attackers. Snickers, again lacking a learning curve, has gotten sick from them more than once, but this has yet to deter him—the joy of toad-hunting seems to be worth the risk. Neither sickness nor failure discourages him. Snickers has caught a grand total of zero toads.

Age 3 years	Breed Yorkshire terrier
Weight 12 pounds	Favorite Food String cheese
Favorite Toy Squeaky shoe	

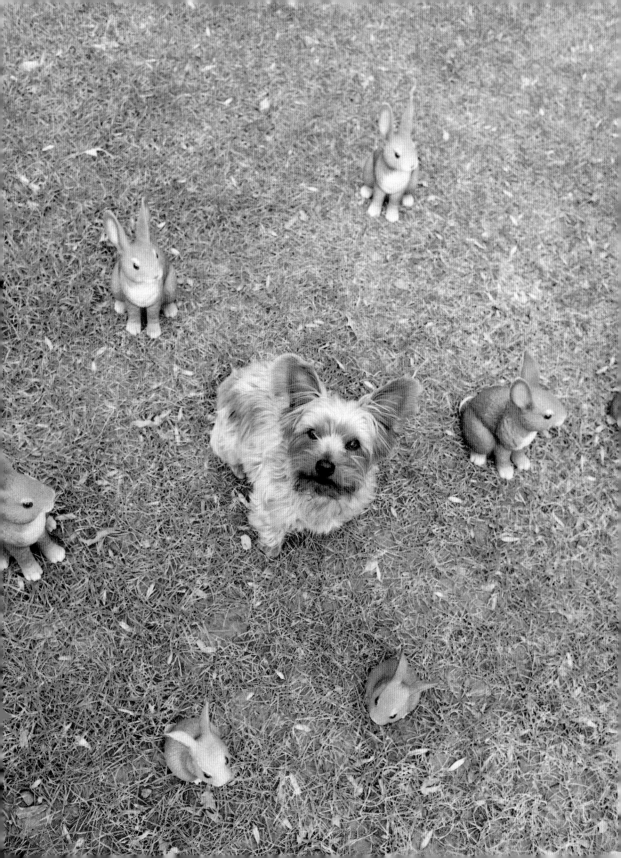

KOHO

BOXER

MADDIE

MOST UBIQUITOUS

"No Dogs Allowed" means nothing to Maddie. Not only because she is unable to read, but also because in Maddie's world she can go anywhere. Maddie suffered from a bit of separation anxiety in her younger days, so her owner just started taking her everywhere. She happily tags along to the drugstore, the post office, the bank, the florist, the video store, the drycleaner—she has even gone shopping at Saks Fifth Avenue! Many of these destinations even offer friendly pats and dog treats. Her favorite errand is a trip to the local hardware store, where not only are there dog treats, but they are self-serve! Maddie is more than happy to help herself to several of these on the way in and, if she can manage it, on the way out as well.

Maddie does not like being left behind. Once, while visiting at a friend's beach house (and after acclimating Maddie to the new house for what seemed like a reasonable amount of time), Maddie's owner decided to go for a solo walk on the beach. A beach walk without Maddie? The horror! Maddie's owner soon saw the error of her ways when, within five minutes, a crazed black Lab galloped towards her at full speed. Maddie had escaped, jumping through one of the window screens (luckily, it was on the first floor). There would be no further beach-walking without Maddie.

It's best just to bring Maddie along wherever you may need to go. From the beach to Saks and everywhere in between, Maddie is happy to join you. Excluding her does not guarantee that she won't show up anyway. "No Dogs Allowed"? Maddie thinks otherwise.

Age 11 years	Weight 80 pounds
Breed Black Labrador	Favorite Toy Glow-in-the-dark ball
Favorite Food Whatever the people are currently eating	

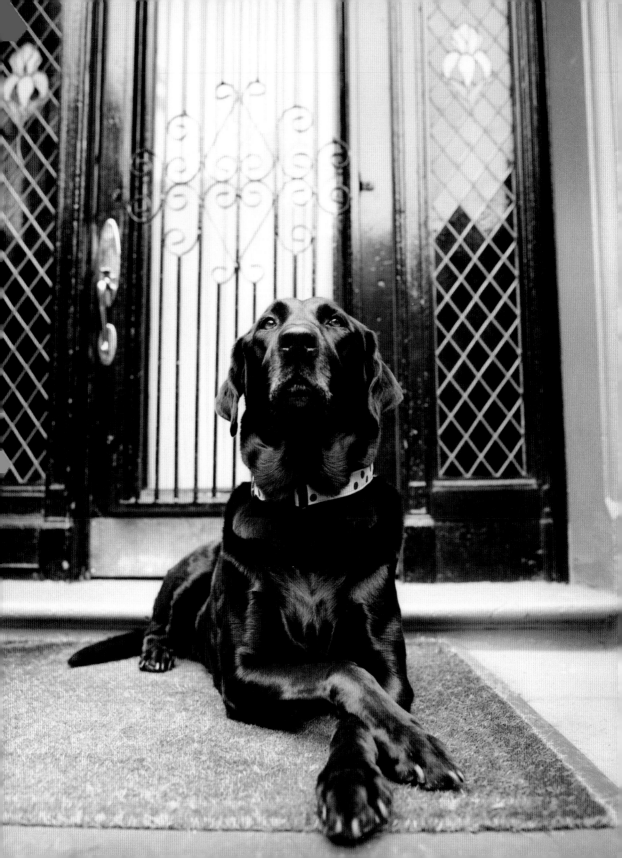

POGO

Pogo gives new meaning to the term "lap dog," because he likes nothing more than running laps around the trails in the woods. He runs so fast that his owner has taken up mountain biking in order to keep up with him, and even with a bike it can be a challenge. Pogo is not just fast; he has amazing endurance as well. He normally runs up to five miles of trails at a near-greyhound pace. (And he's not chasing some fake rabbit around a track!)

Pogo has even joined a team of mountain bikers. Pogo loves to run with the group; it brings him right back to his pack-animal roots. He runs in middle position, so that he can keep an eye on everyone. If a rider should happen to fall behind, or stop, Pogo will not lose sight of that rider until everyone is back in place. Occasionally, Pogo assumes the lead, or Alpha dog, position and chooses the trail for the pack of bikers. This can be problematic, because Pogo is a showoff at heart and will go out of his way to leap over rocks, logs, and puddles. He doesn't really consider the difficulty involved for the less agile bikers—the trail less traveled is the trail most exciting to Pogo.

Pogo runs year round, regardless of the weather. Summers can be extremely hot, but Pogo knows the value of hydration; he takes frequent drinks from clear streams along the way and cools off in any muddy puddles he comes across. Winters are often very icy and can be quite harmful to a dog's precious paws. Pogo avoids injuries by wearing very stylish running boots, reinforced with extra leather padding that also helps with traction on the ice. These reinforced boots do last longer, but Pogo is still actively searching for a shoe sponsor. Hello, Nike?

Age 6 years	Weight 23.2 pounds
Breed Boston terrier	
Favorite Food HIS! (He has no idea what the humans eat.)	
Biggest Fear That he really is a dog	

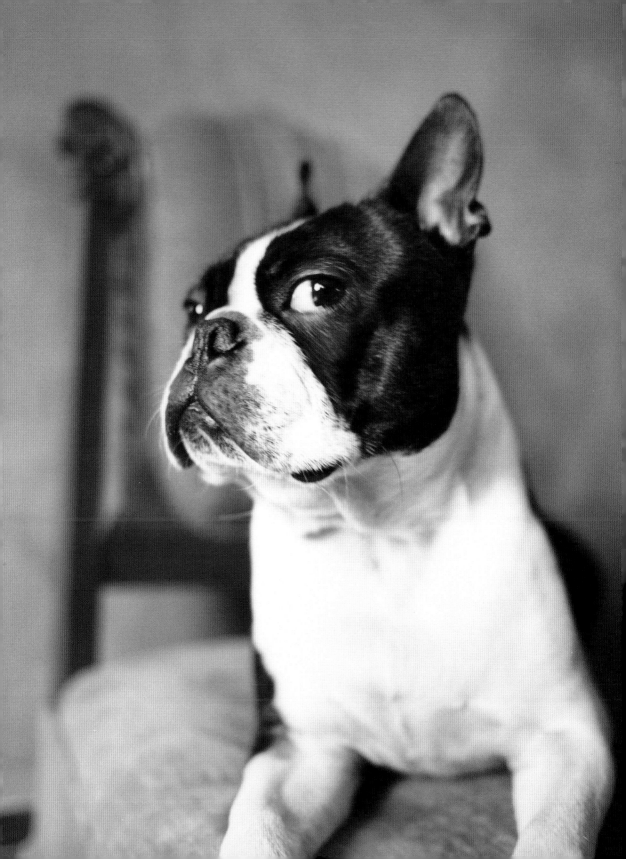

KIBBLES

Kibbles was raised by a pack of dogs. Well, a pack of two dogs, anyway. (Max and Sunny, to be specific.) This probably accounts for her identity issues: She has just always considered herself to be one of the dogs. When she hears, "Who wants to go outside," Kibbles, the indoor cat, runs with her dog sisters to the back door. She never gives up hope that someday she'll be allowed to run out into the yard with them and joyfully chase squirrels. Kibbles eats her sisters' dog food from their dishes and drinks water out of their bowls. She is an expert at the game of fetch and is even easily faked out, just like a dog (although she does not find this to be very amusing, and one fake throw usually ends the game). Kibbles is so in touch with her dogness that she has even learned to drool and beg for food. She loves to join her dog sisters in watching the humans eat. This is not passive observing; she will stare down the eaters and paw at them incessantly until food morsels are reluctantly distributed to both her and the dogs. This behavior has of course endeared her to her dog sisters.

Other cats might be offended at Kibbles' dog characteristics—and her rejection of the cat lifestyle (among other things, she comes when called, allows her belly to be rubbed, and just says no to catnip). But Kibbles has enjoyed great happiness and satisfaction in her life as a dog and sees no reason to change it. The dogs accept her as one of their own and that is good enough for Kibbles. That said, those who are allergic to cats should probably avoid visiting Kibbles, because even though she is a dog in spirit, she does remain a cat in form. (But don't tell her that.)

Age 16 years	Weight 7 pounds
Breed Catbradoodle	Favorite Food Pringles
Favorite Toy Whatever pen you are using	

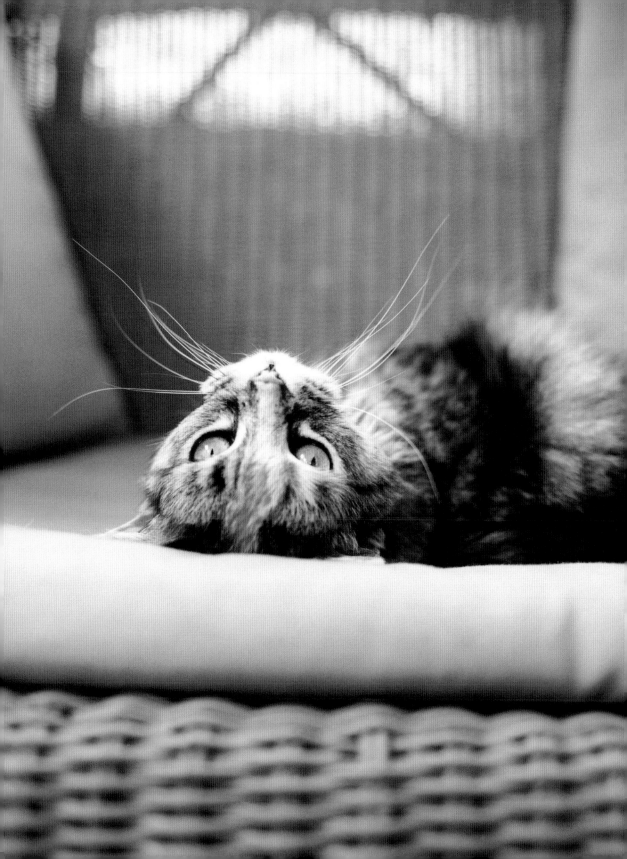

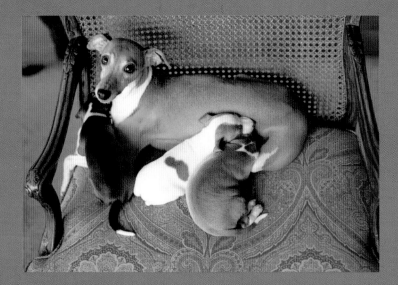

ARMANI

ITALIAN GREYHOUNDS

BELLA

Bella takes the phrase "sing for your supper" quite literally. She's a coonhound, and coonhounds are known for their unique vocalizations. Her dinner song is particularly distinctive, starting off with an attention-getting staccato rap that segues into an elongated single-note howl. Bella can hold on to a note longer than Celine Dion and is happy to do so until her food dish finally appears. Then, like the good diva dog that she is, she bows (right into her dinner bowl).

Bella only sings *a capella*, but she will often harmonize with her older sister, Blue. The two coonhounds don't really have inside voices, or if they do, they just opt not to use them. They tend to get a little competitive with each other in terms of volume and their songs will sometimes crescendo into an all-out forte fest. Their audiences (and neighbors) are not very receptive to these songs and the concert will usually be abruptly stopped. Intermission is called, and it usually takes place in the dog crate.

Bella sings the blues when she has to go to her crate. Crate time elicits a long, mournful howl that is as heartbreaking as an old Bessie Smith ballad. Bella definitely knows how to work the crowd, and sometimes her blues interpretations will get her and Blue out of the crates a little sooner than planned. Once freed from the time out, she will excitedly run to her big sister and sing a joyful, high-pitched, celebratory song, which serves as an invitation to play—or maybe she's just saying, "Encore!"

Age **7 months**	Weight **55 pounds**
Breed **Bluetick coonhound**	Favorite Food **Carrots**
Favorite Toy **Nylabone** (or whatever toy her big sister Blue has)	

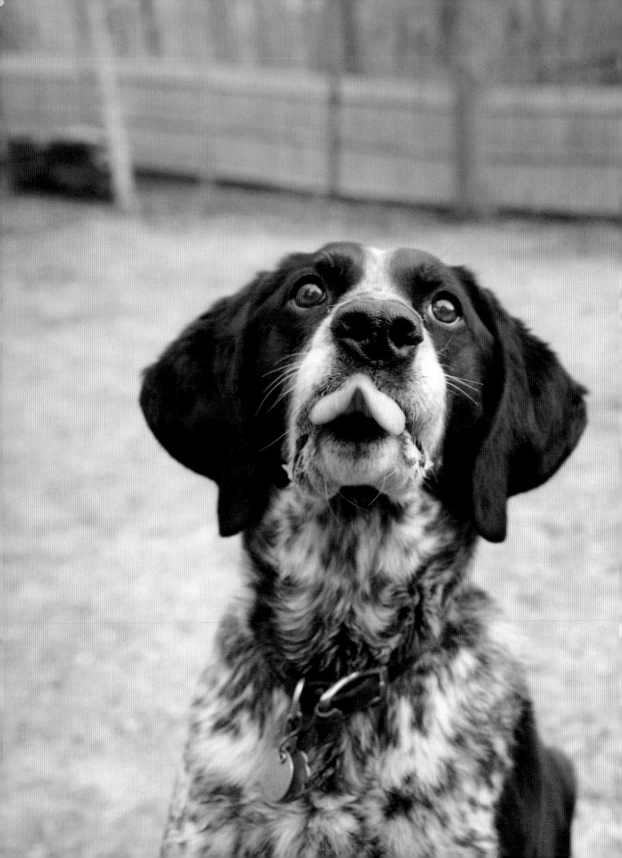

BLUE & BELLA

HILDA

Hilda gets what she wants. And what she wants is what you've got. The food you are eating must be better than the food she is eating. It's not that she does not enjoy her own food; she just would like to enjoy your food as well. She will stare longingly into your eyes while you eat, and if that doesn't work, the whimpering begins. If you do not succumb to this combination, the head-shaking routine begins. It is now almost impossible to finish your meal without giving Hilda at least a bite of it. Of course you realize the ramifications of this positive reinforcement, but it's just too hard to deny her the happiness that your meal provides her.

Hilda also values comfort, and it seems that you are always more comfortable than she is. Your pillow (which, by the way, matches Hilda's own pillow) just looks so much more inviting than hers. So when you've gotten into bed for the night and Hilda is on her pillow next to you, don't be surprised to open your eyes and find that she is sitting up, hovering over you, plotting her next move. Once she has your attention, she will start to circle around and around on her own pillow, widening her path onto your pillow. Suddenly she lies down and she's taking up half of your pillow (and if you're not careful, she's taking up half of your face as well). Don't try to get crafty and use her pillow, as then she will just want that one back. Hilda can provide hours of entertainment for insomniacs.

Even more than food and comfort, Hilda values your attention. It makes no difference where your attention is directed—if it's not towards Hilda, it is clearly in the wrong place. But don't worry; Hilda is always happy to remind you that you are not focusing properly. If you are at your desk, Hilda will come over and stare at you. You may not have noticed her at this point, so she will then let loose a single ear-piercing bark. If you are still ignoring her, Hilda will get one of her rawhides and fling it wildly around the room. Hilda has surprisingly good aim and has been known to score direct hits to the head. Neglect that and she will now start angrily scratching at your legs. You can tell her to go lie down, but Hilda is deaf so your words are lost on her. Pay attention to Hilda. Your personal safety depends upon it.

Age 8 years	Weight 21 pounds
Breed Chocolate cocker spaniel	Favorite Toy SuperBall
Favorite Food All food	

WILBUR

Wilbur should be an agility dog. Not because he's quick and nimble (he's actually a bit of a klutz), but because he has had to overcome many obstacles in his life. First, he managed to make his way out of a kill shelter, no small task for any dog, let alone a pit bull puppy. Wilbur's situation was made more difficult by the fact that he is an albino pit bull, and albino dogs tend to have more health problems than "normal" dogs do. Things were not looking good for Wilbur—unfortunately, they were not sounding good either, for not only is Wilbur an albino pit bull, he is also deaf. Even a deaf golden retriever puppy would have a hard time getting adopted. The odds were definitely stacked against poor Wilbur.

One day a kindhearted rescue person walked in and immediately fell in love with Wilbur's gentle, goofy demeanor. She knew that Wilbur would not last long in the shelter and so she took him home as one of her foster dogs. Wilbur had won the dog lottery. Now he just needed to find his forever home. His foster mother had two other dogs, to whom Wilbur instantly took a liking. Socializing a puppy is very important, and even more so for a deaf pit bull puppy. Wilbur enjoyed being social. He may have enjoyed it a little too much, as his older step-siblings were not inclined to play twenty-four hours a day, as Wilbur would have liked them to. But he soon learned when enough was enough and everyone got along very well. His deafness was barely apparent around the other dogs as he picked up on their cues and reacted to their reactions. He even started barking occasionally.

Misfit Wilbur was fitting in very well to his new home, temporary as it was. His socialization skills were top-notch; he was great with dogs and with people. He almost seemed to be overcompensating for the pit bull reputation; he was extremely gentle, sensitive, and loving. Once it had seemed that Wilbur would be very lucky ever to find a home, but as it turns out, the people who adopted Wilbur were really the lucky ones.

Age 7 months	Weight 25 pounds
Breed Pit bull	
Favorite Toy Bunny rabbit stuffed animal	
Favorite Food Popcorn with real butter	

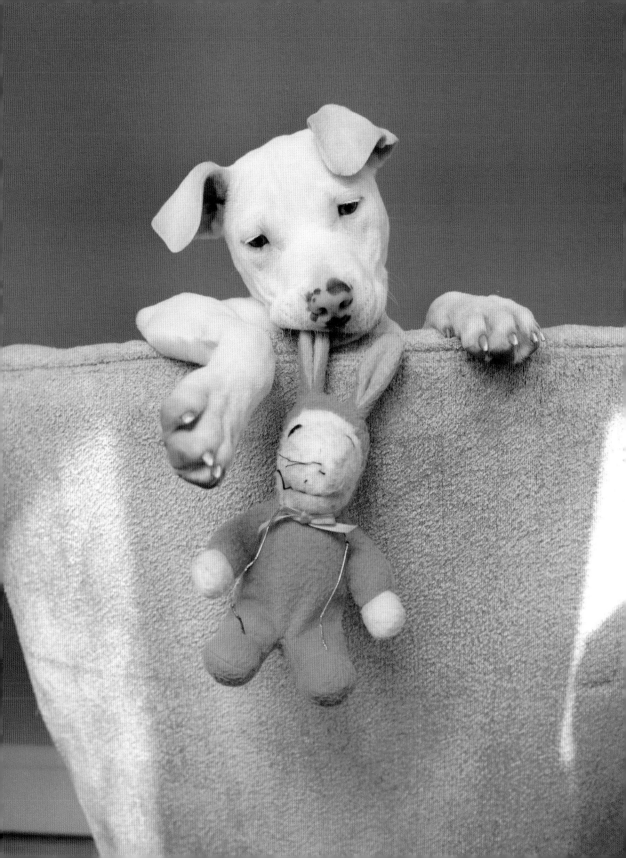

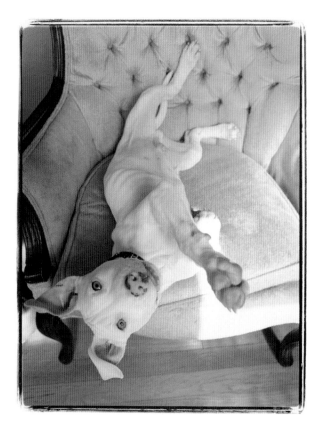

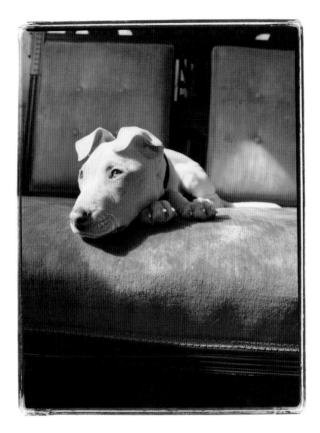

TUCKER

In this corner, weighing in at 13 pounds, we've got Tucker "Wiener-Takes-All" Costello, a shorthaired dachshund from Philadelphia. In the other corner, weighing in at a lean and mean 8 pounds, we've got Oliver "Claws-A-Lot" Costello, an orange tabby cat also from Philly. This matchup is meaningful on so many levels: Male vs. Female (Oliver being the female), Dog vs. Cat, Purebred vs. Stray, Black vs. Orange . . . the implications are enormous and complex. But before this epic battle is fought, we should take a look back at the history of this intense rivalry.

It all started when Oliver was a cute, innocent-looking little kitten. Tucker was thrilled to have a new playmate in the house, especially one who was smaller than him, for it seemed that he would finally be able to have the upper paw during playtime. (Tucker had up until then been dominated by his older and larger brother, Porter). Playtime for Oliver and Tucker always evolved into wrestling matches. These matches were fair fights in the beginning, when Tucker still held a considerable size advantage over Oliver. They would tumble around the living room floor, Tucker with tail wagging joyfully, unaware that the sounds Oliver was making were not the sounds of a happy, playful kitten, but the sounds of a ferocious feline in the making who was planning on dominating this wrestling dog fool.

As Oliver turned from kitten to cat, her size almost that of Tucker's, she turned the tables and started actively stalking him. She would put her "game face" on, sitting with ears pinned back, eyes the tiniest of slits, breathing rapidly and heavily with tail whipping furiously behind her. Tucker would eventually trot by—tail wagging, not a care in the world, oblivious to the danger lurking around the corner. In a quick blast of furry orange fury, Oliver would pounce. Fur (of the dog variety) would fly as they wrestled around the room. Tucker quickly realized that Oliver had become a merciless mountain lion of a cat. He managed to maintain his happy-go-lucky nature, but he now actively avoids Oliver.

And there's the starting bell! The confident and savage Oliver makes his move to the center of the ring, and Tucker . . . wait, where did Tucker go?

Age 8 years	Weight 13 pounds
Breed Shorthaired dachshund	Favorite Toy Half & half
Biggest Fear Oliver	

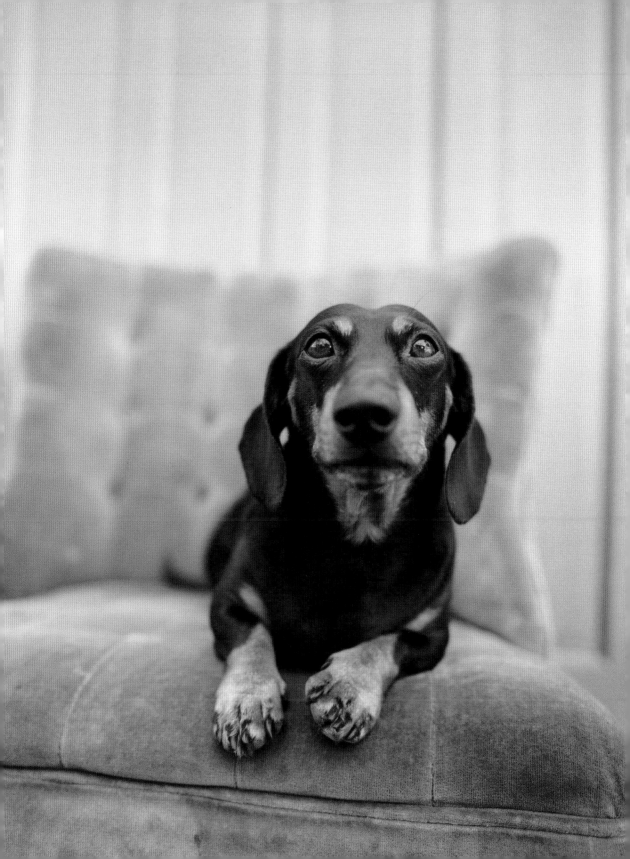

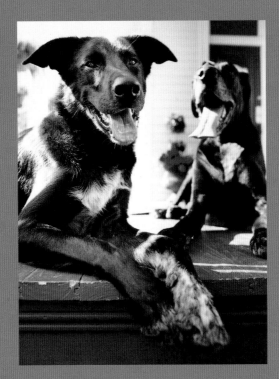

RILEY & HOOVER

SCOUT

Scout has an internal clock that rivals the precision of a Swiss watch. Most dogs seem to have food-based internal clocks, knowing exactly when it's time for a meal. Scout's clock tells her when it is her bedtime. At precisely 9:00 pm every night, Scout gets up, takes a casual look around the room at her humans as if to say, "You guys staying up?" and saunters off to the bedroom. This happens every night like, well, clockwork. It doesn't matter what she is doing or what is going on in the house. She could be sound asleep on the couch and she will still wake herself up right at 9:00 and go to the bedroom to continue sleeping. Even a party attended by lots of fun dog-loving people and handy food opportunities does not delay Scout's nightly departure.

Once Scout has retired for the evening, her loud snoring seems programmed to remind you that it really is time for bed. You can adjust the volume on your television but you will still hear Scout's bedtime call. Once you give in, you might find it a challenge to get much sleep yourself if Scout is on your bed. She has a habit of taking up two-thirds of the bed, leaving very little room for humans. Once you have found some space, Scout will inevitably stretch out her four legs, pushing you closer and closer to the edge.

After a long restful night (for Scout anyway), Scout will still sleep late into the morning. She has no set wake up time and seems to adhere to the motto "Early to bed and whenever to rise." It's not that her internal clock doesn't work in the morning; she just chooses to press the snooze button.

Age 7 ½ years	Weight 130 pounds
Breed German shepherd/ St. Bernard/Lab/Newfoundland/Grizzly mix	
Favorite Food Hummus, Brussels sprouts, string beans, and spinach	
Favorite Toy Enormous tennis ball	

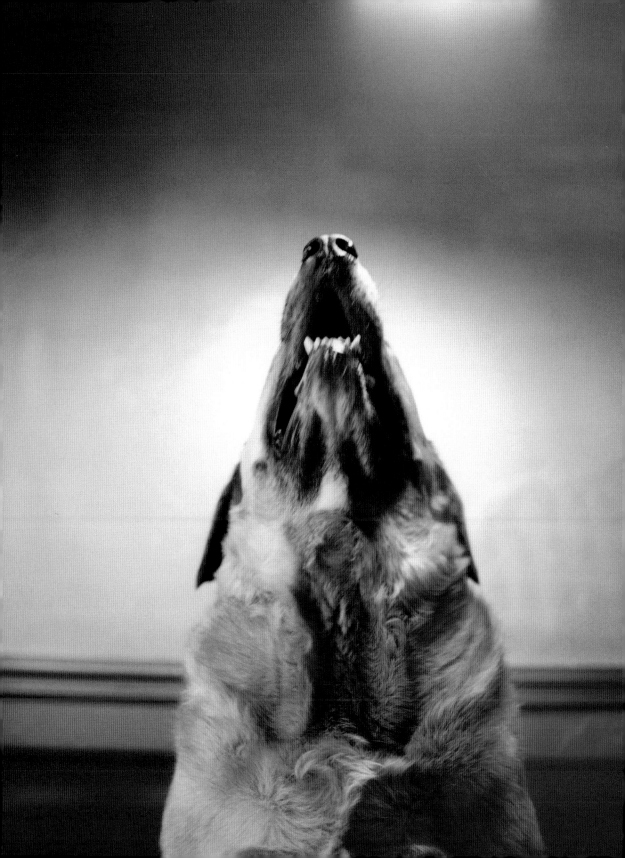

HOUDINI & FREDDIE

STEALTHIEST SOCK SWIPERS

The household at 258 Kent Street has a serious case of MSS, or Missing Sock Syndrome. Socks began mysteriously disappearing from Kent Street about eleven years ago, and reports of missing socks have increased greatly in the past four years. The fact that Houdini became a household member eleven years ago and Freddie within the past four years is no coincidence. The sock culprits are known; their method remains a mystery.

Freddie and Houdini have never actually been caught red-pawed, but it is clear that they are the perpetrators of the sock smuggling. They are always near the scene of the crime and seem suspiciously fond of laundry day. Dirty socks are their preferred bounty—the dirtier the better. The laundry hamper is nothing but a big toy-box to Freddie and Houdini. They are high-quality sock hunters, preferring colorful, expensive socks over the boring white ones that come in multi-packs. A freshly worn argyle is the crème de la crème of socks to the four-footed burglars.

You will most likely never be able to wear a recovered stolen sock again. It's not enough for Freddie and Houdini to steal the socks; they must also kill the socks, stretching them into unwearable forms featuring poodle bite–sized holes. Most found socks are pronounced dead at the scene.

Preventative measures are the only hope of minimizing the number of casualties. Household humans must diligently keep their laundry baskets secured, bedroom doors must routinely be kept shut, and socks must always remain on feet until they can be put into a safe location. These sock-saving strategies are not enough to thwart all of the laundry pilfering, but they do help.

There is only one temporary cure for MSS: sandal season.

Age 11 and 4 years	Weight 10 and 9.5 pounds
Breed **Toy poodles**	
Favorite Food **Everyone else's food, all food**	
Favorite Toy **Eyeglasses and food, glorious food**	

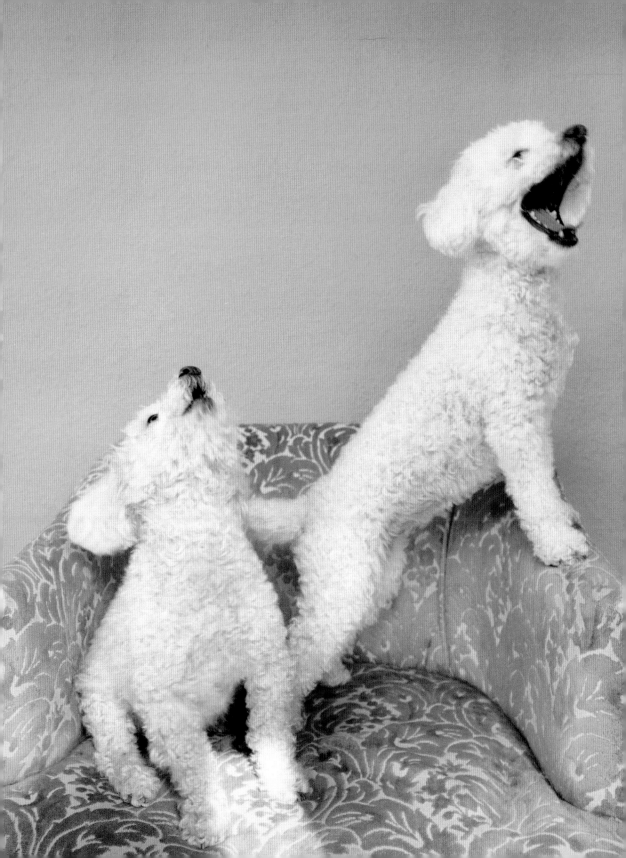

CHESSIE

BEST BARGAIN

"Attention shoppers: today's everyday low-price specials include free puppies, located at the front of the store." This was not a real announcement, but it is actually how Chessie came to be adopted. Someone had decided that a big-box chain store would be a good place to abandon a litter of newborn puppies, and they were deposited at the front door. Employees decided that a rescue group would probably be better able to handle the puppy merchandise, so they called a local rescue team to help with the situation.

An unsuspecting shopper, just making a quick run to the store for a welcome mat, couldn't resist stopping to look at the adorable puppies. The woman in charge of the pups offered to let her hold one of the "chocolate Labs." The shopper, being a big sucker for little puppies, accepted one of the cute little pot-bellied puppies into her arms, and then into her life.

A friend soon commented that the dog looked more like a Chesapeake Bay retriever than a chocolate Lab, and that is how the name Chessie originated. Chessie's cute little pot belly turned out to be a not-so-cute belly full of worms, and the resulting thousand dollars' worth of vet bills more or less canceled out her discount price tag. It also soon became clear that she was a pit bull—perhaps with a little chocolate Lab or Chesapeake Bay retriever mixed in, but she definitely had a long line of pit bulls in her blood. (Not that there's anything wrong with that.)

Still, Chessie did turn out to be a high-quality purchase. The fact that she wasn't a Lab, wasn't a Chesapeake, and certainly did not turn out to be "free" didn't seem to matter, as Chessie became the owners' new best friend. Welcome mat: $12; newborn "chocolate Lab" puppy: $0; de-worming of said puppy: $1000; best friend for life: priceless.

Age 6 years	Weight 60 pounds
Breed Pit bull mix	Favorite Food Chicken
Favorite Toy An old, beat-up, squeaky stuffed rabbit	

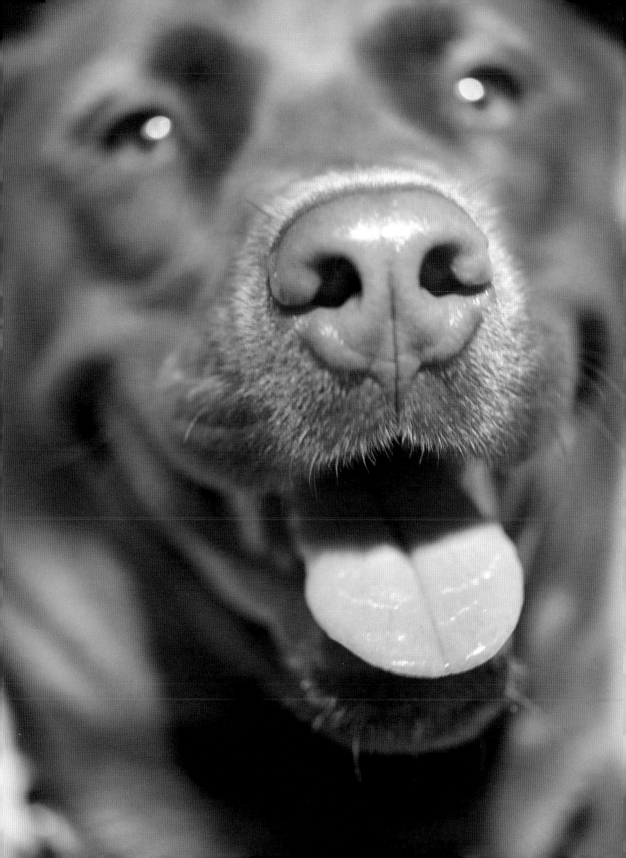

MAX

LONGEST REACH

Max was blessed with an extendable front leg. It looks normal enough, until something tasty gets left on the kitchen counter. Max will wait for the perfect moment, when "there is food on the counter" intersects with "nobody is watching." She will then stand on her back legs and extend her front leg as far as necessary to reach the delicious reward. If you measure the height and depth of the counter, it would seem impossible for a dog of Max's size to reach as far as she has. Nobody has actually witnessed her counter attacks, so the only possible explanation (other than the cat—Kibbles—acting as an accomplice) is her ability to extend (and retract) her front leg.

Max has enjoyed a very high success rate, and over the years she has managed to reach and devour many loaves of bread, several bags of chips, an entire peach pie (she ate the whole crust but left the peaches), a bottle of olive oil (which later turned the house into a vomitorium), countless bagels, many packs of gum, a can of tuna (unopened—she crushed the whole can with her teeth and somehow managed to squeeze out every bit of tuna), and a pint of cream (she wasn't able to get the carton off the counter, but she did manage to knock it down so that the cream spilled over the edge, mostly dripping onto her head). It's not always pretty, but Max is all about substance over style.

Max also uses her superdog powers to reach the back of the bathroom sink. This has allowed her much more variety in her conquests. She has enjoyed many tubes of toothpaste, a very expensive mouth guard, several Chapsticks, and one tube of long-lasting lipstick (which ended up on Max's lips and paws and was indeed *very* long-lasting). Max's scoring opportunities have decreased drastically over the years, as food items are rarely kept on the kitchen counter anymore and all bathroom items are now kept in the medicine cabinet. But Max doesn't give up; she can always count on the occasional houseguests who don't know about her powers…yet.

Age 14 years		Weight 50 pounds	
Breed Shepherd/Husky mix		Favorite Food Baby carrots	
Favorite Toy The cat			

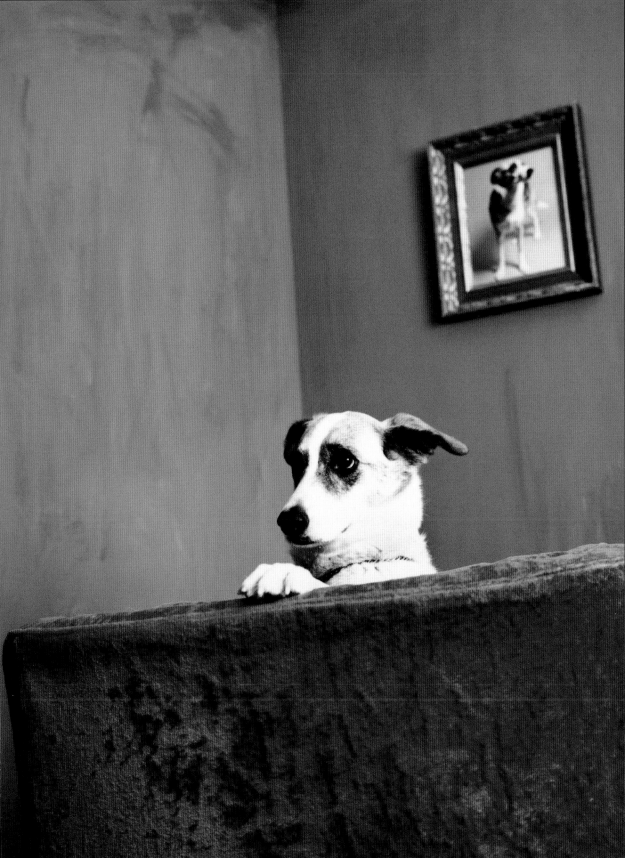

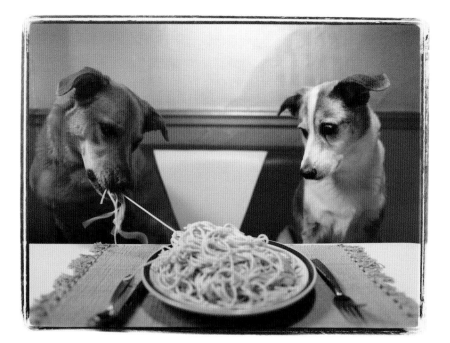

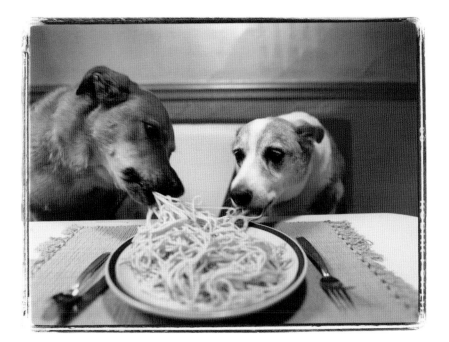

FLO

Flo spent the first five years of her life popping out puppies—thirty-two puppies, to be exact, an average of eight pups per litter. All that puppy-popping left Flo pooped. Breast-feeding and puppy management were exhausting and seemed to be never-ending. Just when one batch of puppies was weaned and sent off to their new homes, another batch was on the way. Flo could not help but think that the phrase, "Life's a bitch!" was created with her in mind.

After her fourth litter of golden puppies, Flo's breeding days were over, and she was adopted into a new home. She is now the pampered puppy of the house, a role reversal that she enthusiastically embraces. Instead of offering her belly to eight hungry puppies, she now offers her belly for loving rubs. She enjoys a much more leisurely schedule, which goes something like this: eat, sleep, play, have treats, sleep, go for a long walk, eat, and once again sleep. These are definitely the golden years for Flo, and she sleeps soundly knowing that she is now only responsible for one human.

Rearing thirty-two puppies was quite the motherly feat, and retirement from all that whelping suits Flo just fine. She certainly has not experienced empty-nest syndrome. After creating thirty-two goldens, she has found her own pot of gold at the end of the rainbow, and the saying that now comes to mind is, "Life is rich!"

Age **7 years**	Weight **59 pounds**
Breed **Golden retriever**	Favorite Toy **The outdoors**
Favorite Food **Polka Dog Bakery treats (Peanut Butter Medley flavor)**	

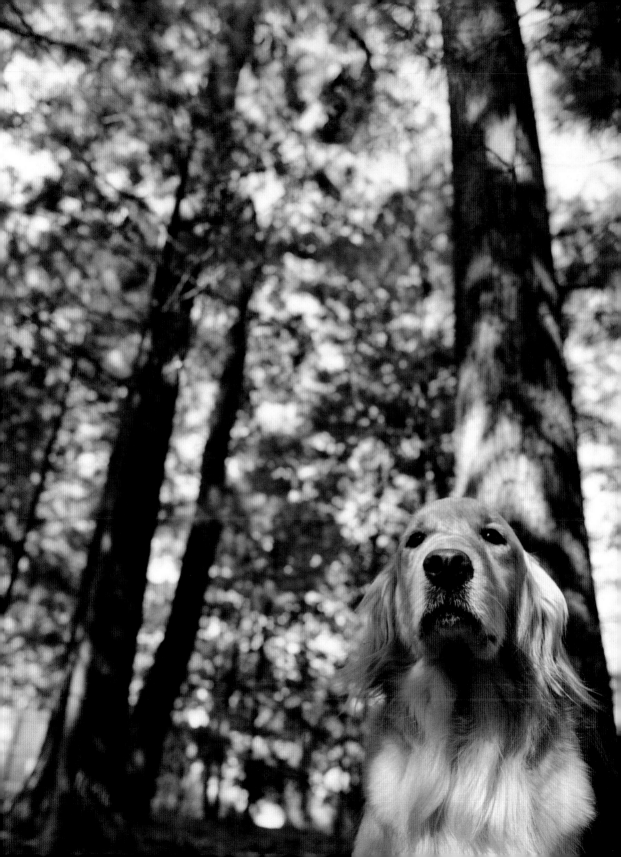

LONGHAIRED DACHSHUND

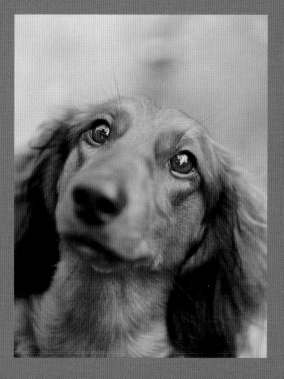

EMMA

ROMEO

BEST OFFENSIVE TACKLE

Are you ready for some football? If so, go visit Romeo. He loves visitors, or, as he thinks of them, visiting teams. And visiting teams need to be tackled upon their entrance to his home field. Romeo has perfected the art of the tackle. Many dogs (at least those who have not been paid a visit by the Dog Whisperer) simply jump up on guests when they arrive. Romeo doesn't stop there. He jumps up a few feet away from the guest and then propels his entire body forward in the air, landing full force onto the person. Luckily, Romeo is not very tall and only weighs 55 pounds, but he can still generate enough power to knock over a small unsuspecting adult. Children should enter the arena at their own risk.

Romeo loves it when a whole team of guests comes to visit. He runs from guest to guest, body-slamming each one of them, bouncing off of one and hurling his chest into another. It starts to resemble football players celebrating a touchdown in the end zone. Romeo is, however, the only one celebrating. Guests find Romeo's celebrations to be amusing at first, but as the body-slamming continues unabated, they soon cry out, "Unsportsmanlike behavior!" and Romeo's owner is forced to send him to the sidelines.

During the off-season, Romeo loves to go for long walks. He uses these walks to stay in shape and to practice new tackle moves. He will occasionally take his owner down by charging at the back of her knees. This does of course constitute clipping, but with no referees around, he escapes the normal 15-yard penalty. When Romeo meets a new person on his walk, he practices his blocking technique, jumping at the new person with the goal of clearing a path for his owner. This is usually very successful, as Romeo's owner will not stop to talk to the new person (other than to apologize for her dog's etiquette) and will rush through, chasing after Romeo. Romeo then turns back to see that his owner has made it through the defensive line, thinking to himself, "Touchdown!"

Age **7 years**	Weight **55 pounds**
Breed **English bulldog**	Favorite Food **Ice cream**
Favorite Toy **Pink pig**	

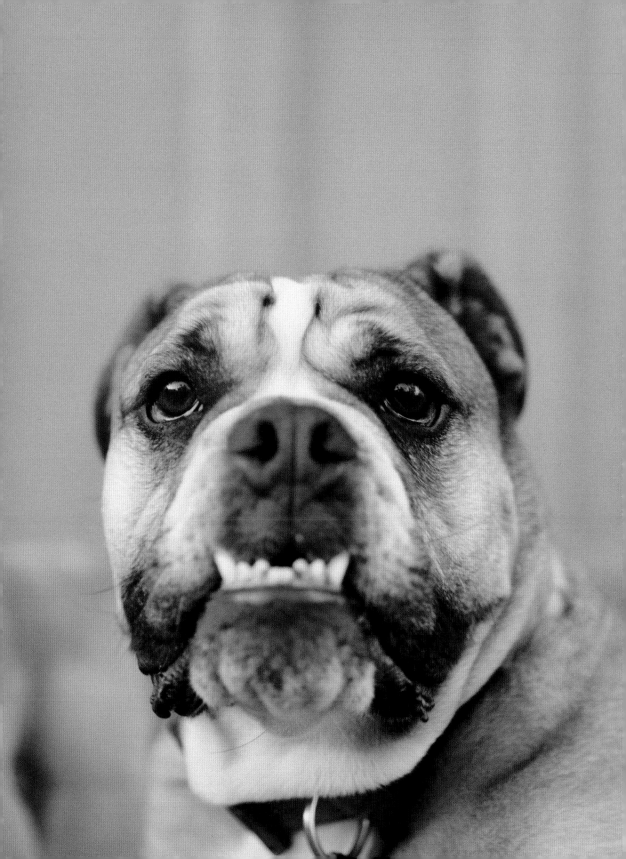

DAILEY

It's 6:00 in the morning, and Dailey's got work to do. She wakes up her owner (or, as Dailey views her, her coworker), and by 6:15 they are out the door and going for what looks to be your average, run-of-the-mill dog walk. But watch closely, and you will see that Dailey is on a mission she takes very seriously.

The newspapers in Dailey's neighborhood are left at the foot of each driveway. To Dailey, this is unacceptable. She sits down next to the first paper she encounters, until her owner picks it up and delivers the paper to the front door. Dailey follows her owner up to the door to ensure proper paper placement. Once satisfied that the newspaper is in its rightful place, Dailey runs to the next driveway and the process is repeated. This continues until the entire neighborhood (there are about twenty houses on Dailey's route) has received their "Dailey" paper.

Dailey's owner has tried to train her to not only spot the newspapers, but to complete the actual delivery as well. Dailey has been reluctant, or maybe just too smart, to learn this extra step. Of course, her owner made the mistake of attempting this on a weekend, with a Sunday paper bigger than Dailey. Dailey was not receptive to doing this extra work. As far as she is concerned, the current division of labor is optimal.

Age 3 years	Weight 8 pounds
Breed Yorkie-poo	Favorite Food Ice Cream
Favorite Toy Her German shepherd brother	

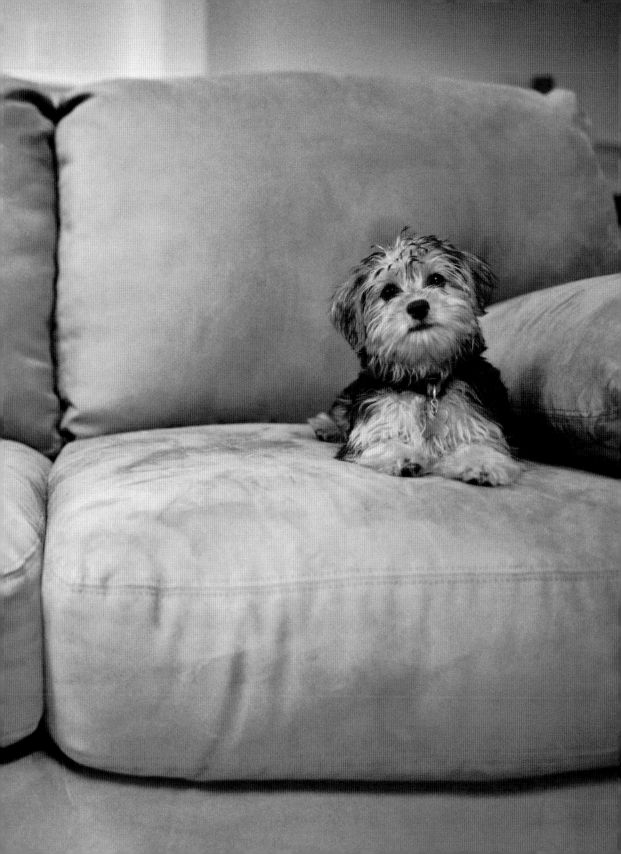

COLLIE RESCUE DOGS

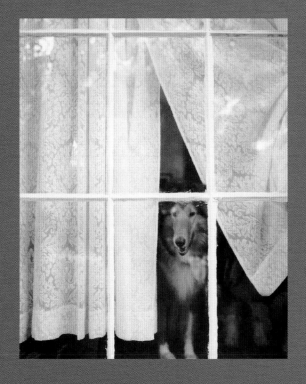

HALEY

SUNNY

WORST PATIENT

Sunny loves everyone. She loves kids, strangers, the mailman, other dogs, even cats—she just loves everyone . . . well, almost. She absolutely hates the vet. She hates the vet's office, she hates the vet techs, she hates the drive to the vet, she hates the word "vet"—she even hates those cutesy reminder cards that come in the mail once a year.

Sunny's vet and the vet staff are some of the nicest people in the world, and if Sunny ran into any of them on the street, she would love them like she loves everyone else. But something just happens to Sunny when she walks into the vet's office. She's developed quite a reputation there—they all know her name doesn't quite match her disposition. The happy, gentle, friendly, must-lick-your-face dog turns into an out-of-control, raging lunatic. She doesn't really try to bite anyone, but a muzzle is usually employed, just in case. It's her legs and claws that cause the most danger; they fly around like helicopter blades (with Ginsu knives attached) at full speed. The only one drawing blood at the vet's office is Sunny, and she has managed to do that several times.

Her file is full of big lettered warnings such as "MUZZLE!" and "RESTRAIN!" and even "GOOD LUCK!" The vet techs draw straws to see who will be stuck trying to help with the examination. Want to check her ears? Be quick, you might get about four seconds per ear. Heart rate? Way off the chart, don't even bother. Teeth? Well, that's easy, she's happy to show those off. Clip her nails? Not going to happen. Vaccinations? Bring in two more brave vet techs and don't forget the sedatives.

Age 7 years	Breed Rhodesian ridgeback mix
Weight 72 pounds of lap dog	Favorite Food Cheese
Favorite Toy The new one	Nickname Sunny Girl

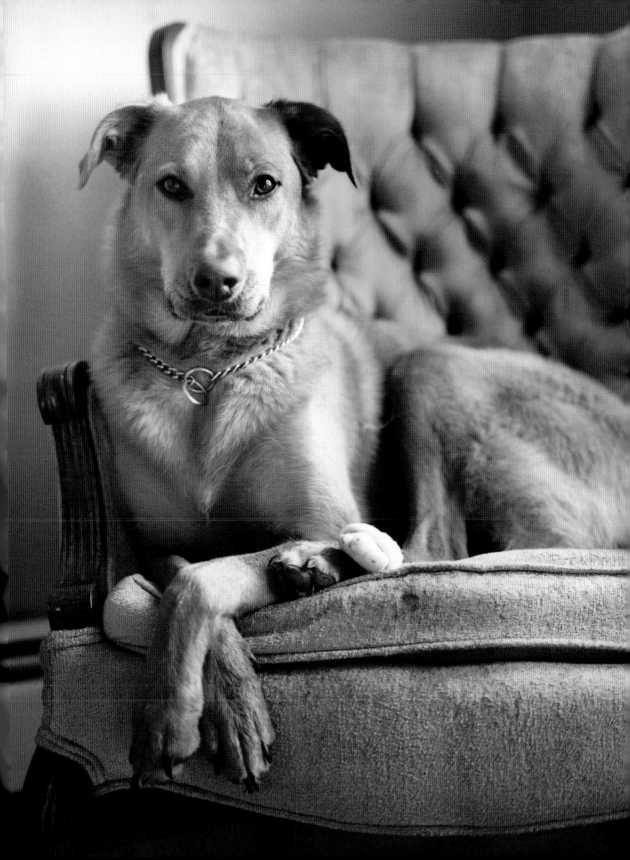

SUNNY

WINNIE

GUTSIEST SKY DIVER

It's a bird! It's a plane! It's a . . . Jack Russell? That's right, Winnie can fly, or at least she thinks she can. And believing you can do something is the first step. The second step usually results in Winnie plummeting from whatever elevation she has climbed. Winnie puts the terror in terrier (at least she puts the terror in her terrier owner). Winnie has mastered takeoffs and landings, but the flying itself still needs some work—or maybe some wings.

Jack Russells are known for their jumping ability, but they will usually jump straight *up*, reaching heights of six or seven feet. Winnie prefers to jump *down* from such heights. She just finds that it's easier, and more fun, to fall six feet down than it is to propel herself six feet up into the air. Winnie's love of falling, paired with her breed's typical fearlessness, is a dangerous combination. It can be especially perilous on mountain hikes, and Winnie is quite the hiking enthusiast. There's nothing she likes better than reaching the summit of a tall rock, briefly admiring the view below, and then leaping straight into the abyss. Luckily, Winnie's owner has become quite adept at catching her kamikaze dog in mid-jump. This, and Winnie's catlike ability to land on all four paws, has certainly saved her from many injuries.

Even in her older, but perhaps not wiser, age, Winnie can be found sauntering over to the edges of tall staircases and furniture. She seems to put a little more thought into the pre-flight ritual, but the results are usually the same: twenty-one pounds of wingless dog plunging to the ground below. Prepare for landing, Jack Russell incoming!

Age 14 years	Weight 21 pounds
Breed Jack Russell terrier	Favorite Food Red meat
Favorite Toy Rugby ball	

ACKNOWLEDGMENTS

Deepest gratitude to: Asia Kepka, best friend and most masterly rogue dog-wrangler; my Dad, most enthusiastic supporter and wittiest writing assistant; my Mom, most inspirational artist and formidable freelancer; and all of my beautiful supermodels and their superowners.

Thank you also to: Ann Treistman for getting this project started and guiding me through it from beginning to end; Alissa Faden for the beautiful design; the New England School of Photography for the education and the use of their darkrooms; David Akiba for shaping my visual perception; Ken Foster for the excellent foreword and for all of the dog rescue work he does; and all of my friends and family for their constant support and encouragement.

Sunny would like to thank all of the staff at Dr. Looby's vet office, for being so kind and patient with the Worst Patient.

Kibbles would like to thank all who believe in her dogginess.

Max would like to thank everyone who has ever left anything edible within her reach.